DRAWING IN

CHARCOAL AND CRAYON

FOR THE USE OF

STUDENTS AND SCHOOLS

BY
FRANK FOWLER

Copyright © 2013 Read Books Ltd.
This book is copyright and may not be
reproduced or copied in any way without
the express permission of the publisher in writing

British Library Cataloguing-in-Publication Data
A catalogue record for this book is available from the
British Library

Drawing and Illustration

Drawing is a form of visual art that can make use of any number of drawing instruments, including graphite pencils, pen and ink, inked brushes, wax colour pencils, crayons, charcoal, chalk, pastels and various kinds of erasers, markers, styluses, metals (such as silverpoint) and even electronic drawing. As a medium, it has been one of the most popular and fundamental means of public expression throughout human history – as one of the simplest and most efficient means of communicating visual ideas.

Drawing itself long predates other forms of human communication, with evidence for its existence preceding that of the written word – demonstrated in cave paintings of around 40,000 years ago. These drawings, known as pictograms, depicted objects and abstract concepts including animals, human hands and generalised patterns. Over time, these sketches and paintings were stylised and simplified, leading to the development of the written language as we know it today. This form of drawing can truly be considered art in its purest sense – the basic forms on which all others build.

Whilst the term 'to draw' derives from the Old English *dragan* (meaning 'to drag, draw or protract'), the word 'illustrate' derives from the Latin word *illustratio*, meaning 'enlighten' or 'irradiate'. This process of 'enlightenment' is central to drawing and illustration as we know it today. Medieval codices' illustrations were often called 'illuminations', designed to highlight and further explain

important aspects of biblical texts. This was the most general form of illustration; hand-created, individual and unique. This changed in the fifteenth century however, when books began to be illustrated with woodcuts – most notably in Germany, by Albrecht Dürer.

The first creative impulses of a painter or sculptor are commonly expressed in drawings, and architects and photographers are commonly trained to draw, if for no other reason than to train their perceptual skills and develop their creative potential. Initially, artists used and re-used wooden tablets for the production of their drawings, however following the widespread availability of paper in the fourteenth century, the use of drawing in the arts increased. During the Renaissance (a period of massive flourishing of human intellectual endeavours and creativity), drawings exhibiting realistic and representational qualities emerged. Notable draftsmen included Leonardo da Vinci, Michelangelo and Raphael. They were inspired by the concurrent developments in geometry and philosophy, exhibiting a true synthesis of these branches – a combination somewhat lost in the modern day.

Figure drawing became a recognised subsection of artistic drawing in this period, despite its long history stretching back to prehistoric descriptions. An anecdote by the Roman author and philosopher Pliny, describes how Zeuxis (a painter who flourished during the 5th century BCE) reviewed the young women of Agrigentum naked before selecting five whose features he would combine in order to paint an ideal image. The use of nude models in the medieval artist's workshop is further implied in the writings

of Cennino Cennini (an Italian painter), and a manuscript of Villard de Honnecourt confirms that sketching from life was an established practice by the thirteenth century. The Carracci, who opened their *Accademia degli Incamminati* (one of the first art academies in Italy) in Bologna in the 1580s, set the pattern for later art schools by making life drawing the central discipline. The course of training began with the copying of engravings, then proceeded to drawing from plaster casts, after which the students were trained in drawing from the live model.

The main processes for reproduction of drawings and illustrations in the sixteenth and seventeenth centuries were engraving and etching, and by the end of the eighteenth century, lithography (a method of printing originally based on the immiscibility of oil and water) allowed even better illustrations to be reproduced. In the later seventeenth and eighteenth centuries, the previous combination of the arts and sciences in drawing gave way to a more romantic and even classical style, epitomised by draftsmen such as Poussin, Rembrandt, Rubens, Tiepolo and Antoine Watteau. Mastery in drawing was considered a prerequisite to painting, and students in Jacques-Louis David's Studio (a famed eighteenth century French painter of the neo-classical style), were required to draw for six hours a day, from a model who remained in the same pose for an entire week!

During this period, an increasingly large gap started to emerge between 'fine artists' on the one hand, and 'draftsmen' / 'illustrators' on the other. This difference became further complicated with the 'Golden Age of Illustration'; a period customarily defined as lasting from the

latter quarter of the nineteenth century until just after the First World War. In this period of no more than fifty years the popularity, abundance and most importantly the unprecedented upsurge in quality of illustrated works marked an astounding change in the way that publishers, artists and the general public came to view artistic drawing. Arthur Rackham, Walter Crane, John Tenniel and William Blake are some of its most famous names. Until the latter part of the nineteenth century, the work of illustrators was largely proffered anonymously, and in England it was only after Thomas Bewick's pioneering technical advances in wood engraving that it became common to acknowledge the artistic and technical expertise of illustrators. Such draftsmen also frequently used their drawings in preparation for paintings, further obfuscating the distinction between drawing/painting, high/low art.

The artists involved in the Arts and Crafts Movement (with a strong emphasis on stylised drawing, and a powerful influence on the 'Golden Age of Illustration') also attempted to counter the ever intruding Industrial Revolution, by bringing the values of beautiful and inventive craftsmanship back into the sphere of everyday life. This helped to counter the main challenge which emerged around this time – photography. The invention of the first widely available form of photography (with flexible photographic film role marketed in 1885) led to a shift in the use of drawing in the arts. This new technology took over from drawing as a superior method of accurately representing the visual world, and many artists abandoned their painstaking drawing practices. As a result of these developments however, modernism in the arts emerged – encouraging 'imaginative

originality' in drawing and abstract formulations. Drawing was once again at the forefront of the arts.

There are many different categories of drawing, including figure drawing, cartooning, doodling and shading. There are also many drawing methods, such as line drawing, stippling, shading, hatching, crosshatching, creating textures and tracing – and the artist must be aware of complex problems such as form, proportion and perspective (portrayed in either linear methods, or depth through tone and texture). Today, there are also many computer-aided drawing tools, which are utilised in design, architecture, engineering, as well as the fine arts. It is often exploratory, with considerable emphasis on observation, problem-solving and composition, and as such, remains an unceasingly useful tool in the artists repertoire.

The processes of drawing is a fascinating artistic practice, enabling a beautiful array of effects and creative expression. As is evident from this short introduction, it also has an incredibly old history, moving from decorations on cave walls to the most advanced, realistic and imaginative drawings possible in the present day. It is hoped that the current reader enjoys this book on the subject.

CONTENTS.

PART FIRST.

CHAPTER I.

CHARCOAL AND CRAYON DRAWING. . . 1

CHAPTER II.

OUTFIT NECESSARY FOR CHARCOAL AND CRAYON DRAWING. . . . 4

CHAPTER III.

ELEMENTARY PRACTICE. . . . 25

PART SECOND.

CHAPTER IV.

MANNER OF WORKING. , , . 36

CONTENTS.

CHAPTER V.

MEASUREMENT, ACTUAL AND COMPARATIVE. 50

CHAPTER VI.

CRAYON PORTRAITS; HAIR; DRAPERY; BACKGROUNDS. 58

CHAPTER VII.

CHARCOAL AND CRAYON DRAWING WITH THE POINT; LANDSCAPES; PROPORTIONS, ETC. 74

APPENDIX.

EXPLANATION OF THE PLATES. . . 82

PREFATORY NOTE.

This little volume, with accompanying plates, is designed to prepare students for the interesting study of drawing from life. The general demand for a work of this kind is the occasion of its appearance.

DRAWING IN CHARCOAL AND CRAYON.

CHAPTER I.

CHARCOAL AND CRAYON DRAWING.

IN learning to draw, charcoal is the most available material that can be used, as, with it, large and striking effects are so easily and quickly produced, while it is also adapted to the most careful work, and may be carried on to any degree of finish. Another quality which renders charcoal especially of value as a medium for beginners in drawing is that it is so easily erased.

Charcoal is used for drawing from the cast and from the human figure in all the large art schools of Europe as well as in

our own country, and is especially adapted to sketching from nature, as by its use most charming landscape and marine effects may be obtained.

TWO DIFFERENT METHODS.

There are two methods of working in charcoal—one, in which the charcoal point is used alone, the shading being put in with lines which are not blended, no stump, or rubbing together of any kind being allowed.

This style of drawing is principally used in illustrating, as it is more easily reproduced than those in which the stump is used. Full details of working in this manner will be given later.

The other method is that in which the charcoal is blended with a stump, no lines being visible in the modeling.

This manner of drawing is that most generally employed in art schools, and is susceptible of higher finish than the other.

It is also in this way that charcoal and

crayon portraits are managed, such drawings being generally finished with crayon, and the two materials worked together. This subject also will be treated at length further on.

As we are writing for the benefit of those who have no knowledge whatever of charcoal drawing, we will begin at the very beginning, and shall endeavor to omit nothing that can be of practical use to the student.

CHAPTER II.

OUTFIT NECESSARY FOR CHARCOAL AND CRAYON DRAWING.

THE first thing to be provided is an easel, which is used now entirely for drawing, it being considered much better practice to work in an upright position than in the old-fashioned way of leaning over a table.

This easel may be of the simplest character, and is made of three straight bars of pine wood jointed so as to stand upright, with holes perforated through two of the bars about two or three inches apart. Through these holes pegs are stuck upon which to hold a narrow wooden tray. Upon this the stretcher, drawing-board, or portfolio is placed.

DRAWING-BOARD.

This board is made from any light wood,

and should measure about 20x24 inches

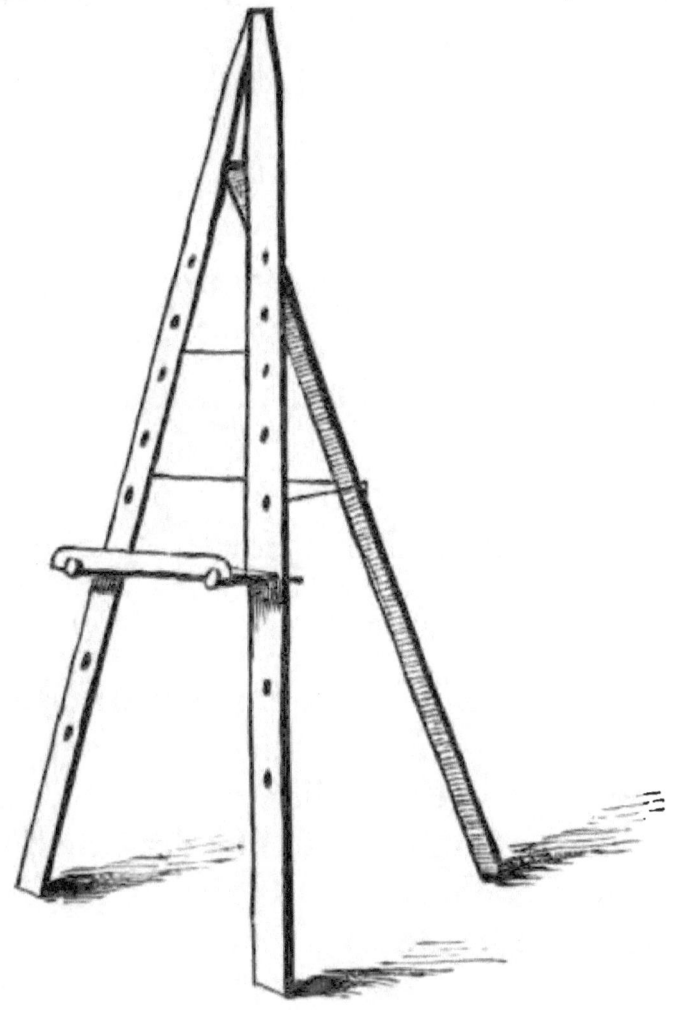

THE EASEL.

square, and be as thin as it can be made without warping.

In place of the drawing-board, many artists prefer to use a large pasteboard portfolio made with covers stiff enough to serve as a foundation in drawing, while its convenience as a receptacle for the reserve sheets of paper and finished work is obvious.

The portfolio which is now most in use, is generally covered with smooth mottled paper outside, and should be large enough to hold without folding the regular sheets of charcoal paper; 20x24 inches will be sufficient for this.

THE PAPER.

There are a great many varieties of charcoal and crayon paper, some smooth, some rough. For ordinary purposes, such as making studies and life drawings, the rough French charcoal paper is the best. That used in the French schools is of two kinds; the roughest is called the "Michelet" paper, and the other is known as "Lalanne." They are, however, very similar in texture, and either one will serve

the purpose. These come in sheets of uniform sizes, costing from three to six cents each.

For more careful drawings, such as finely finished portraits in charcoal and crayon, a more expensive paper is to be preferred. This comes in much larger sheets and should be stretched before using.

Whatman's rough crayon paper is among the best for this purpose. In all cases, both for studies and finished portraits, the white paper, generally a yellow-white, being preferable to blue-white.

HOW TO STRETCH PAPER.

Paper is stretched and mounted for this work in the following manner: A simple frame of wood is made an inch or two wide and three-quarters of an inch or more in thickness, according to the size of the drawing to be made. This is covered with cotton cloth stretched as tight as possible and tacked all along the

four sides. The cloth is turned over and tacked on the outside of the stretcher, not on the face of it, which should present a perfectly smooth, flat surface.

The paper having been cut the proper size, that is, large enough to turn over nearly an inch all around, is dampened on the wrong side. To do this take a clean cloth dipped in cold water, lay the paper flat upon a table and pass the cloth rapidly all over the surface, wetting it evenly.

Have ready some good flour paste and put this all around the edge of the paper for about an inch. Now begin to spread the paper while still damp upon the cloth-covered stretcher, starting at the bottom and working upward, carefully smoothing out with the hands all creases or air bubbles. Turn over and press down the edges of the paper which have been covered with the paste, holding them till they stick to the cloth, and cut a V-shaped piece from each corner of the paper, so that it will fold over neatly.

This takes time and experience to do well, but is worth the trouble, for crayon portraits especially.

For ordinary studies and drawings, the Michelet or Lalanne paper fastened to the portfolio or drawing-board with thumb tacks is quite sufficient.

CHARCOAL.

There are many different kinds of charcoal offered by dealers. All that is necessary, however, is a medium quality of imported charcoal, such as the Fusains Venitians, costing 30 cts. a box of fifty sticks. Finer and more expensive kinds are the Conte and Rouget charcoal

CRAYON.

Among the various manufactures of crayons that most generally preferred by artists is the French crayon Conté. This comes in several numbers, and is to be had in two forms. First, the wooden pencils, which are very convenient, and again, the short sticks of black crayon,

which are sold by the dozen. These are much cheaper than the pencils, and are fastened in a holder while using. The Conté crayon No. 2 is sufficient for all purposes, therefore it is unnecessary to have the several different numbers so often recommended.

Another kind of crayon is also used by some artists in addition to the stick crayon. This is a fine, black, powdered crayon, called the "sauce crayon," and comes put up in little tin cases. It is very useful when large masses of dark are necessary, and is rubbed on with a stump, while the stick crayons and charcoal sticks are sharpened to a point before using.

Stumps are made variously of leather, chamois-skin and paper. The most useful in charcoal and crayon drawing are the paper stumps, which will be found to answer every purpose. The paper stumps come in two forms; first, the gray, rough paper stumps with points on both ends; these are made in various sizes, from the smallest, which measures only about one-

fourth of an inch in diameter, up to those measuring an inch and more.

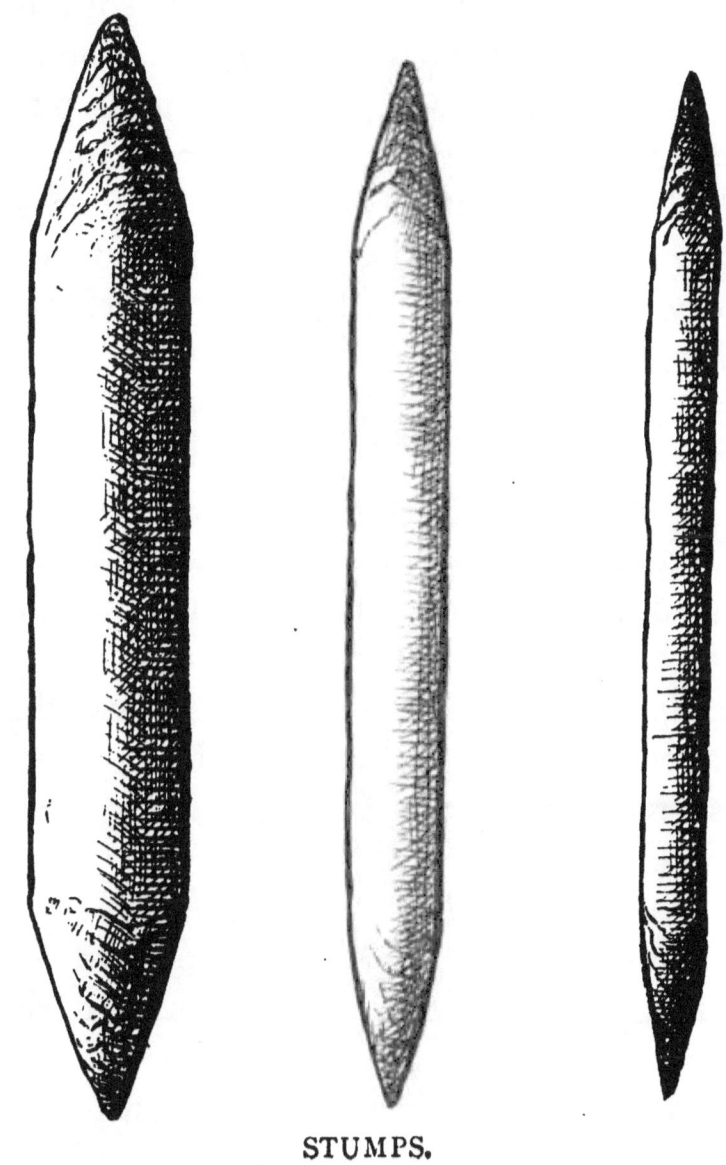

STUMPS.

The other form of paper stump, known as the tortillon, is made of strips of paper rolled to a point like spills, and sold in bundles of a dozen for a few cents. Some artists prefer these, but for general purposes, the double-pointed paper stump is the best. About six of these are necessary: two large, two medium, and two very small ones; for it is always better to have a clean duplicate of each size.

BREAD.

A supply of the soft part of home-made, if possible, or good ordinary baker's bread, one day old, is indispensable. This should not have any butter, or even milk, in its composition, otherwise it will grease the paper, which naturally should be avoided, as grease spots are most difficult to overcome.

The bread is used for rubbing out charcoal or crayon, erasing mistakes, and for taking out lights from a mass of dark. The soft crumb is rolled between the fingers until a point is formed, and then

applied to the paper. It is surprising what brilliant effects can be obtained by means of this simple process; its full resources can only be understood by practice.

THE RUBBER STUMP.

This consists of a long, narrow bar of fine artist's rubber, ground to a point on each end. It is used for rubbing out small spots in places where the bread can not be so easily managed, and where a firmer point is needed.

It is also useful in modeling fine details of the features, and in places where, the surface of the paper being worn by rubbing, the bread will not act satisfactorily.

These cost from five to ten cents each, according to size.

RAGS.

A fine, soft cotton rag is one of the most important adjuncts to our outfit, as it is impossible to work without one. The rag is used sometimes to dust off charcoal

from the paper, and if the charcoal has not been very heavily used, the rag is often sufficient, neither bread nor rubber being necessary.

A rag is also useful when too much charcoal or crayon has been rubbed on a tone.

Let us say, for instance, a shadow appears too black. A soft rag is passed gently over the surface, taking care not to rub too hard, and the superfluous charcoal or crayon will come off, leaving a beautiful soft tone of much lighter quality behind.

This tone can of course be darkened somewhat, or worked over in any manner desired.

The rag is often used in sketching landscapes, to spread a smooth, even tint for the sky. Many artists prefer it to a stump for this purpose. A fine, soft cotton rag is rolled in a long, smooth roll, and applied lightly to the surface of the paper.

The charcoal may be powdered in such

a case if preferred, or for crayon drawing the " sauce crayon " is used.

TO " FIX " DRAWINGS.

Charcoal will of course rub off, and drawings become smeared and defaced if left unprotected. For that reason it is customary to " fix " the drawing by the application of some preparation to its surface.

This should be done with much care, and only the very best materials should be used for this purpose. Amateurs and students sometimes endeavor to manufacture fixative for themselves out of shellac and alcohol. This may succeed in fixing the drawing, but will be very liable to turn the paper yellow in time. Artists, therefore, prefer to buy an imported fixative, which is made by a reliable manufacturer. That most generally in use, and which we have found by experience to be in every way satisfactory, is the *Fixatif Rouget*, which comes in good-sized glass bottles, costing at retail fifty cents each.

There are two methods of fixing drawings. First, that in which the fixative is applied to the back of the drawing. This is preferred by some artists; and the French students, who are only anxious to preserve their drawings, without regard to the changing of color in the paper, use milk, with which they wash over the back of the drawing.

In cases where a large design or cartoon is made in charcoal for temporary use, this way will answer perfectly, being very much less expensive than the other. The fixative Meusnier, which is imported by all dealers, is also applied to the back of the paper with a large brush.

The other method, and that generally preferred, is to apply the fixative to the front or surface of the drawing.

This process should of course be managed with care, as too much fixative will cause the charcoal to run down in streaks, while too little will cause it to come off in spots.

The fixative for applying to the surface

CHARCOAL AND CRAYON. 17

of the drawing is sprayed through a glass atomizer by blowing through one tube while the other rests in the bottle containing the liquid.

These atomizers are now sold by all art dealers, and may be had from the simplest and most inexpensive kind up to those represented by quite a costly apparatus. The cheapest consist of two small tubes of glass, pointed at one end and straight at the other. These are connected by two bands of metal, which in turn are fastened together by a small hinge or pivot.

This is so arranged that the two tubes of glass meet at a right angle, the small pointed ends coming in contact, but so as to leave both orifices open.

One end, as already mentioned, is now placed in the fixative, while through the other the breath is blown. This causes the liquid to mount in the lower tube and dissolve in a cloud of spray which is so light as not to dislodge the delicate particles of the charcoal and yet will

attach them firmly to the paper, so that ordinary rubbing will not efface the drawing.

Great care should be taken in blowing through an atomizer to make the breath as steady as possible, avoiding short, unequal puffs. The atomizer must not be held too near to allow the particles to vaporize sufficiently, or else the fixative will run down in streams and ruin the drawing. Again, if held too far off, it will vaporize too much, and will fail to fix the charcoal at all.

The more expensive vaporizers, while conducted on the same principle, are supplied with air from one or sometimes two rubber globes or balls, which have the advantage of transmitting the air in a regular stream, and one is thus saved the fatigue of blowing with the mouth, which, in case of a large drawing, becomes very tiresome.

These atomizers are generally made with metal tubes, which will become clogged and useless unless washed out after

using each time, with warm water. The simple glass atomizers must also be kept clean in this way, for they are very easily broken if a pin is used to clean the openings, and the slightest break at the joints renders them useless.

OUTFIT FOR SKETCHING.

Charcoal is used by artists for sketching out of doors in preference to any other material, as by its means such quick results are obtained and large effects produced with comparative ease.

As one never knows how long a tramp will be necessary before the proper subject or view appears, it is well to make every thing as compact as possible.

A small sketching easel which can be reduced to a thin bundle of sticks is considered indispensable by some, but as this is rather awkward to carry, most artists prefer a block.

THE BLOCK, OR PAD.

This consists of a number of sheets of

charcoal paper, cut exactly the same size, laid together and pressed so as to greatly reduce the bulk of the paper in its ordinary shape. These form a block or table of sufficient substance and firmness to be held comfortably upon the knees while sketching.

The upper leaf is used for the drawing, and is then loosened with a penknife passed around the edges, which are held together with a band of paper. This leaf is then easily detached from the block, and being fixed is laid aside while another drawing is commenced on the clean sheet exposed on the top of the block.

These blocks can be bought already prepared at any good art dealers at reasonable prices, which vary according to the size and quality of the paper.

A block made of ordinary French charcoal paper measuring $4\frac{1}{2}$x6 inches costs at retail, 25 cents. A small block like this is only good for pocket sketches and notes. A more useful size is 6x9, which may be obtained for 35 cents.

A still larger one, measuring 10x14, can be procured for 70 cents. Any thing beyond this must be made to order, and will in that case be more expensive in proportion.

A small camp stool is necessary to the sketching outfit, and this should be made as light as possible. These are made in various shapes, so as to fold up as tightly as possible, and are provided by all dealers at from fifty cents up.

Some are even to be found combined with the sketching easel. These are very convenient, being made in so compact a form as to occupy very little more space than either an easel or camp stool separately.

Such an apparatus costs $5.50 at retail. The small, light folding easel for sketching, which is only 4 1-2 feet high, costs $2.50, while a stool which stands upon three legs when open and folds into the shape of a thick cane can be bought for $1.00.

THE UMBRELLA.

A sketch can not be truthful to nature and carefully studied, with the sun shining in one's eyes or upon the paper; it is therefore well to be provided with an umbrella.

The sketching umbrella is generally of creamy white or very light gray cotton. It is so constructed as to be separated from the long stick upon which it is arranged when in use, this stick itself being divided into two or more parts, according to its length. These are arranged to fit into each other firmly, the lower end terminating in a long, sharp iron point which is to be planted in the ground.

The umbrella itself is furnished with a rather short handle, and is attached to the long staff by a movable screw joint which permits of its being arranged at any angle necessary to protect the sketcher from the sun.

The whole outfit complete with a waterproof gingham umbrella costs $8.00.

The long folding stick is sold separately. This is 6 ft. high with an adjustable joint to which any ordinary umbrella can be fastened. These cost about $3.00.

A long and narrow tin box with compartments completes the outfit. This holds the charcoal, crayon, stumps, bread, rag and rubber. The charcoal and crayon must always be kept shut up in their separate compartments, or failing that, in respective boxes, as, if allowed to knock around loosely in the box, they will soil the stumps, rubber and rags.

The paper generally used in sketching blocks is the ordinary grade of French charcoal paper with a rough surface already mentioned. This paper comes in a variety of tints, the most popular being the cream-white and the gray. The white paper is generally preferred for serious studies involving careful drawing and correctness of value.

Some artists, however, prefer to use gray or light brown paper in sketching, as if one is skillful a very effective result

may be obtained with little labor by using the local tone of the paper for the half tints, quickly rubbing in the shadow with charcoal or crayon, both being sometimes used.

The high lights are then cleverly touched in with white chalk or pastel. Chinese white water-color paint is sometimes substituted for the chalk in putting in such lights. It has the advantage of being more permanent in one way as the chalk rubs off, but in the course of time this white paint so used has a tendency to turn yellow, especially if the sketch is shut up in a book or kept from the air.

On the other hand, the white chalk will turn yellow if fixed, so that the high lights must not be put in the sketch until it is all finished and fixed, which is of course a disadvantage to the artist who wishes to study the relations of his tones as he proceeds. This method will be explained at length later on.

CHAPTER III.

ELEMENTARY PRACTICE.

To those who have never had any experience whatever in drawing, it is best to begin with straight lines. This is especially necessary in the case of children, who must first be taught to control the hand before proceeding further.

The next step is to draw curved lines representing half of a circle.

From this proceed to draw angles, circles, squares, and other such simple forms in outline, until the muscles of the hand have learned to obey the will.

The system we wish to teach is first to begin in this way, then to advance gradually by copying some simple drawings, executed in the modern method, until the use of charcoal and crayon is thoroughly understood.

These drawings should be progressive, commencing with the features in different positions, and leading gradually to the full head, feet, hands, torso, etc., until the full length figure is reached.

By this time sufficient proficiency will have been attained to enable the student to put aside copying and proceed to drawing from the cast, when the same progressive studies should be observed until a sufficiently thorough foundation in drawing is acquired to warrant the final step of drawing from life, which is the most difficult though the most interesting of all.

In view of these necessities, a series of studies in charcoal and crayon have been prepared to accompany this volume. These should be carefully copied, according to the directions given.

ARRANGEMENT OF LIGHT.

Before beginning to draw, whether from copies, from the cast, or from life,

it is most important that the room be properly lighted.

If possible a north light should be selected, although that is not absolutely necessary, it is, however, most generally preferred by artists, as the light is more steady, and less influenced by the direct rays of the sun. There should be no cross light, the light coming from one direction only; therefore, if there are several windows on different sides of a room, all should be darkened while working except those on one side.

This light should so be arranged as to come from above rather than from below, and if the window is a long one, curtain off the lower part, so that the light begins about six feet from the floor. If more than one person is working in the same room, several windows on the same side are admissible. If, however, a studio were being built expressly for the purpose, the ideal light would be one large, high side window, extending from six to ten feet along the wall, beginning at the floor

and reaching to the ceiling, where it is joined by a skylight, which is arranged with an adjustable curtain, so that it may only be uncovered when needed. In the same way the lower half of the window should be curtained off up to a height of six feet for ordinary purposes. The whole length of the window is sometimes useful in simulating an out-of-door effect of light.

Some famous painters have had studios built entirely of glass, so that they could have all the advantages of working in the open air without the exposure. Adjustable curtains would turn the glass-house into an ordinary in-door studio, with conventional light. Few of us are so fortunate as to command these conveniences, and truth compels us to admit that they are not strictly necessary to good work.

As we have already stated, the easel is now universally adopted for drawing, as well as painting, instead of the old methods, which necessitated leaning over a

table. The plate to be copied is also placed upright, in the same upright position that would be occupied by a cast or live model, so that, even in this elementary training, the eye becomes accustomed to look naturally from the object or study being copied to the paper on the easel.

When preparing to draw, the easel should be placed in front of the window and so arranged that the light will come from behind, and fall over the left shoulder of the worker.

Two or three sheets of charcoal paper are now firmly fastened to the portfolio or drawing-board, which should in no case be smaller than the paper, but even larger, projecting at least half an inch beyond the regular-sized "Lalanne" or "Michelet" sheets.

To fasten the paper use ordinary flat brass-headed paper tacks, putting one in each corner, and one on each side between, making six in all. The two sheets of paper underneath the one used for drawing are so placed in order to make a firmer

and smoother foundation than could be obtained by spreading a single sheet directly upon the hard surface of the wooden board or portfolio, where any crack, knot, wrinkle, or other imperfection would show through when rubbed with the stump.

This arrangement is of great importance, and should never be neglected.

For the benefit of the actual beginners, we will commence with the drawing of straight lines, which is not nearly so easy as might be supposed.

STRAIGHT LINES.

The foundation of technical skill in drawing of many kinds, notably the charcoal and crayon point, pen and ink, and pencil, depends upon the power of making lines with correctness and dexterity; and though later on, in drawing and painting, we learn to see only by form, almost entirely discarding the line *per se*, yet this early training of the hand often gives firmness and surety of touch to the

painter's brush which might otherwise be wanting, and is in many ways felt to be valuable.

To begin the practice of drawing straight lines, first make two dots of several inches apart, let us say, about three inches from one point to the other. Let these dots at first be perpendicular, one being directly above the other.

Sharpen the charcoal to a point and draw it slowly from the upper to the lower point several times, at first without actually touching the paper, to accustom the eye to the distance; then make the actual line between the two, bearing lightly upon the paper and making a line of uniform thickness.

Make these lines in rows parallel to each other and about an inch apart, continuing the exercise until you are able to make perfectly straight upright lines.

The next exercise consists of drawing horizontal lines in the same manner. After this, oblique lines should be practiced, inclining in different directions.

Remember that no ruling, measuring or mechanical aids of any kind are to be made use of, the object being to train eye and hand.

CURVED LINES.

Curved lines are of course more difficult than straight for those who are entirely untrained. Begin to draw these by making the two dots at first as for the straight line; connect these dots with a very light line, and then through the center draw another line at right angles, dividing the first exactly in two. This line, projecting from one side only, must be exactly the same length as half the first line thus

Now connect the extremity of these lines with a curved line extending from one end to the middle and thence to the other end. When practice has enabled the student to draw these curves correctly, the straight lines are omitted and the curves drawn only from point to point.

Let this simple exercise be repeated by drawing the curves in every direction. When the pupil is able to draw both straight and curved lines thus with ease he has already gained an important step.

After this, simple forms should be drawn in outline, using such copies as 120 studies in free-hand, called "How to Draw," by Chas. Ryan, costing 25 cents, published by Cassell & Company.

A box of blocks should next be procured, which are sold by art dealers for the purpose, and the student should begin with the simplest forms and draw them from nature, in outline at first, progressing gradually to more complicated forms.

The next step is shading, which is done at first in the simplest manner. The

outline sketched in, the proportions are ascertained to be correct and the shadow and light are divided into two great masses without detail and blocked in as broadly as possible, according to the method given in the following pages.

Learn to begin a drawing properly and the finishing will be easy enough, being merely a matter of practice when once the manner of working is understood. How often we see exposed for sale and on exhibition drawings and paintings elaborately finished of which the drawing is so faulty as to render them worthless.

Students, therefore, who are thoroughly in earnest must be content to postpone all idea of finishing at first, occupying themselves in the preliminary studies with correctness of outline and proportion only. For this reason when the shadows are blocked in broadly and the drawing appears to be as nearly right as you can make it, put it aside and take up something a little more difficult and carry it on to the same stage without endeavoring to

elaborate it. Thus continue your practice, always progressing until you feel fitted to begin the study of the human face and form, which is, as we have said, the most difficult thing in art.

PART SECOND.

CHAPTER IV.

MANNER OF WORKING.

Those who have already had sufficient practice in the elementary drawing indicated in the first part, can of course omit the foregoing pages, and begin at once with the preparatory studies of the face and figure, which are necessary before proceeding to drawing from the cast.

These studies consist of eight plates, carefully prepared by the author, according to the modern methods of charcoal and crayon drawing now employed in all large art schools both in Europe and our own country.

By carefully copying these plates in

CHARCOAL AND CRAYON.

their regular order, the student learns the method of using charcoal and crayon, so as to be perfectly acquainted with these materials and their resources before beginning to work from Nature; the design also being to familiarize the eye with the constructional drawing and proportion of the human figure beforehand, thus materially lessening the difficulties of drawing from life. The general manner of working is as follows :—

Arrange the light, place the easel in position, and fasten the charcoal paper to the drawing board or portfolio in the way already described. We will suppose the subject to be drawn is a head. First make a small mark or dot on the paper with your charcoal, to show where the top of the head will come. A corresponding dot will indicate the bottom of the face or chin, while a mark on each side will show the width of the head.

Before beginning to draw a line, these marks will suggest whether the head be properly placed on the sheet. See that

there be not too much space on either side, and that the head is not too high or too low.

If these preliminary precautions be neglected the head may be placed most awkwardly; too much to one side or otherwise wrong, and the mistake not be noticed until the drawing be nearly finished. The importance, therefore, of properly placing the head at first can not be overestimated.

The position being decided, the outlines are lightly sketched in with long, sweeping lines, following the general direction of the head without any attention at first to details of any kind. Let these lines next determine the oval described by the face, sketching at the same time the lines of the throat, and ascertaining the action of the body in relation to the head by one or more long, sweeping lines across the bust from shoulder to shoulder.

Next draw a line with the charcoal point across the oval of the face where the hair meets the forehead, one through

the middle of the eyes, one at the base of the nose, through the center of the mouth and the lowest point of the chin.

These lines determine the proportions of the face, and are drawn very lightly with the charcoal, sharpened to a fine point, as they are erased when the features are drawn in. Next proceed to place the features on these lines, blocking them in only in their general forms at first with very little detail, and draw these forms as squarely as possible, seeking for angles and avoiding curves.

It is easy to turn angles into curves in finishing a drawing, but if we begin with curves we have nothing to depend upon, and the drawing loses strength, becoming soft and weak in the end.

Having ascertained that the features are in the right place, go back to the outline and bring that into shape, though without trying to finish it carefully as yet.

The next step is to block in the shadows in their general forms, dividing the whole head into two distinct

masses of light and shade. To do this, make a faint outline of the exact form of the shadows where they meet the light; now fill in with charcoal all the mass of shadow within the outline, making one flat, even tone of dark without variation of shade. To do this draw the charcoal in straight parallel lines slightly oblique, almost touching each other, until the whole shadow is covered. No special care need be taken in putting in these lines, as the main object is to get the paper sufficiently covered with the charcoal. The largest paper stump is now used, to unite these charcoal lines into one flat tone of dark.

The stump is held in the fingers, so that about an inch of the point lies on the paper, not merely the tip end. With this the charcoal is rubbed in until no lines appear, only one simple even tone of dark filling the outline of the shadow.

Put in the eyes, nose, mouth, etc., and in the same way drawing the form of the general shadow first without any detail,

as already mentioned, and putting in the flat tone with the charcoal and stump.

When the principal shadows are thus laid in, look at the head from a distance and see if the proportions are correct. Any mistake will be easily seen in this stage, and should be corrected at once before proceeding further.

To correct a line or erase the charcoal in any way, use the crumb or soft part of stale bread. This is done by taking a small piece between the fingers, and rolling it into a little ball, then shaping it to a point. Be sure the bread is not too fresh or made with butter, as greasy bread will ruin the paper, so that it is impossible to work nicely on it. If, however, such a grease spot becomes evident when the drawing is somewhat advanced, it can be remedied in the finishing, by touching carefully with a sharp-pointed crayon, and rubbing with a pointed rubber stump; working with both alternately, making fine, small touches, until the spot is even in tone with the rest.

In using the bread, never press hard ; if the charcoal or crayon will not come off, use the pointed rubber stump.

In laying in a mass of shadow, if too much charcoal gets on the paper, so as to become inconvenient, wipe it off lightly and evenly with a soft cotton rag, and if then the tone is too light, work on it again with charcoal, as before, using the stump in the same way until it becomes the right tone.

In working heads, life studies, etc., in charcoal it is the practice in all the large art schools to finish them with black crayon. The crayon is not touched, however, until the shadows are all put in and the proportions found to be correct. The whole effect being blocked in in the way already described, the crayon is taken up and the two materials used together at first, as required, in the following manner :

The outline, which has been sketched in with charcoal, is now very carefully drawn with a finely pointed Conté crayon No. 2. First dust off the charcoal a little

with a rag until the outline is quite light, though easily seen, and do not make the crayon outline too dark and thick.

Next proceed to block in the hair with charcoal. Do this at first in the simple masses of light and shade, rubbing in the charcoal in close lines at first, so as to well cover the paper, and then using the stump to make one flat, even tone.

If the hair is dark, cover the light mass with a general tone of light gray, using the charcoal very lightly and rubbing it flat with the stump as before. If the hair is light, put in a fainter tone for the dark mass and a very delicate tone over the light mass. Do not attempt to see any reflected lights or small details as yet.

Having the head now well started, we proceed to carry it on by putting in the half tints which connect the masses of light and shadow all over the face. Do this with a clean, medium-sized paper stump by dragging the charcoal from the shadow over the light. Do not put any new charcoal on for the half tints, as it is

very important that they be kept light at first. Keep a clean stump always at hand for delicate half tints, and never use an old one.

The face now begins to model and look round, and is further carried on by putting in the dark accents of shadow and taking out reflected lights with bread.

The features are brought into shape, using the sharp pointed charcoal and a small stump.

At this stage the crayon is taken up permanently and the charcoal laid aside.

The Conté crayon No. 2 sharpened to a fine point is rubbed all over the mass of shadow already laid in with charcoal and is then softened with the stump in the manner already described, the charcoal and crayon together producing a beautiful quality of tone.

Let me here mention that some artists prefer to use the sauce crayon for putting in large masses of dark, such as shadows, hair, drapery, etc. The student should

try both methods and use either or both, as he may prefer.

The sauce crayon should be rubbed off on a small piece of charcoal paper and tacked on one side of the drawing so as to be convenient for use.

The point of the large stump is now rolled around in the sauce or powdered crayon thus prepared, and is then rubbed into the shadow until the whole is covered with the crayon and presents an even dark tone.

The sauce crayon is only to be employed for large spaces, and is useful in saving time, as it takes longer to cover the surface with lines made by the crayon point. Still many prefer the latter.

The crayon point is always used in finishing up the drawing, which is carried on by degrees. The dark accents are put in the eyes, nose, mouth and ears, and the small stump is used to soften the marks of the crayon, but should not be rubbed too much.

If the head be rather dark in its general

effect, a very delicate gray tint should be put all over the light mass of the face. This is done with a clean stump which has been used for half tints, and the tone is put on in the same manner, the crayon point not being used here.

The high lights are taken out with the bread rolled to a point, and should be made sharp and distinct. The hair is carried on in the same manner as the face, the dark accents and details being put in with the crayon point and softened a little with the stump. The half tints are developed and reflected lights taken out with bread. The high lights are lastly rubbed out in the same way, taking care always to preserve the exact form of the lights where they meet the shadows.

In drawing hair, do not attempt to put in too much detail. The deepest shadows and the highest lights should always be kept simple. The most detail is generally seen in the half tint, but should be very carefully studied only in the most prominent parts, the rest being left in a suggestive way.

In working thus with charcoal and crayon, there are one or two things that should be always kept in mind.

In the first place, the charcoal and crayon must always be kept sharpened while drawing, a fine point being most necessary. A sharp knife should always be at hand, and also a piece of sandpaper, as it is very difficult to sharpen the crayons with a knife, they break so easily.

Always buy the best materials, and always keep plenty on hand. Have a box of charcoal, and at least half a dozen crayons, and keep one or two clean stumps in reserve no matter how many you have already in use.

In rubbing on charcoal, and before using the stump, be sure to cover the paper well, so that very little rubbing will spread the tone into an even mass. No matter how much charcoal you get on at first, you can always take off the superfluity with a rag; but if there is not enough one is tempted to rub the paper too hard, and if the surface of the paper gets roughened

by too much rubbing at first, you can never do any thing with it afterward.

In putting on the crayon, however, we must be more careful.

Put on a little and try it with the stump; if it does not spread well, add more, and so on. Even when dispensing entirely with the sauce crayon and using only the pointed sticks, it is well to rub off some of the crayon on a small piece of paper and pin it up on one side of the drawing, for using in very light tones where the point must not be employed. For instance, in covering the light side of the face with a delicate tone, the stump is rubbed on this, and tried first on a piece of paper before using it on the drawing.

Never let the hand rest directly upon the drawing itself. If not convenient to rest it upon the margin, have a sheet of clean writing paper to place underneath the hand.

In sketching in, or drawing long, sweeping lines, do not steady the hand upon the paper at all, as one does in

writing, but try to acquire freedom of handling by practice, resting the hand upon the paper only when absolutely necessary, as in drawing fine details, or when great precision is required.

CHAPTER V.

MEASUREMENT, ACTUAL AND COMPARATIVE.

By actual measurement is meant the measurement of the object itself by holding against it a ruler or straight strip of paper, and marking off the number of inches or exact distance from one given point to another. These measurements are then compared with the drawing, and the same distances are marked off on the paper.

In mechanical and architectural drawing this system of measurement is in constant use, but in freehand drawing, and in the method practiced by artists, actual measurement is not allowed. Never measure in any way when beginning a drawing, but strike out bravely, resolving to depend upon the eye only, if possible.

After the first outlines are put in, and the proportions are as nearly correct as you can make them, it is perfectly legitimate to "prove" a drawing by actual measurement, if it is a copy. If one is drawing from a cast, or from life, and it is necessary that the head be exactly the same size, a measurement may be taken from the top of the head to the chin, and compared with the sketch you have made. Beyond this no actual measurement should be allowed.

COMPARATIVE MEASUREMENT.

This is a very important thing in drawing from Nature, or objects of any kind, and must be thoroughly understood by the student, as without it no drawing can be made absolutely correct.

Comparative measurements are entirely *proportional.* The manner of taking them is as follows :

Place yourself opposite the object to be measured, at the same distance from which your drawing is taken. Let us say

you are drawing the bust of Apollo, and wish to discover just the exact height of the whole, also the width across the shoulders.

Extend your arm in a perfectly straight line at right angles to the cast, holding in your hand a long lead-pencil. The pencil must be held parallel to the general direction of the cast, neither end being allowed to swerve the slightest.

Now, closing one eye to concentrate the vision, measure off with your thumb upon the pencil, which is held crosswise, the apparent distance from the outside of one shoulder in a direct line to the outside of the other. Keep your thumb tightly upon the pencil at the place measured, and slowly turn the hand around, keeping the arm extended at the same distance from the body, and the eye in the same position as before.

The pencil is now held straight up and down, and your object is to see how many times the distance measured off on the pencil will go into the whole length of

the cast, beginning at the top of the head and measuring down to the foot of the bust, slowly moving the pencil downward and checking off with the eye each time the measurement is repeated.

In this way we can find out exactly whether the cast is just twice as long as it is wide, or less—in other words, the comparative proportions.

This kind of measurement is invaluable in out-of-door sketching, and the eye soon becomes so trained by practice that relative proportions are compared instinctively, and one scarcely needs to use the pencil.

THE PLUMB LINE.

Another most valuable adjunct in drawing from life and from the cast is the plumb line. This consists of a piece of strong twine with a weight on one end, which serves to keep the string perfectly straight and steady when suspended from the hand. A straight line is thus simulated which is dropped from a given point

to one directly underneath, forming one side of a triangle, which will ascertain for us the different positions that certain other parts assume in relation to this line.

For instance, we hold the plumb line so as to make a straight line from the chin of a standing figure to the ground. The top and bottom of the line form two points of a triangle, the third to be represented by the man's heel.

Imaginary lines are now drawn through these points, forming the triangle, whose base determines the direction of the heel in relation to the center-line of the body. In this way the balance of a figure can be accurately ascertained, and the most difficult action correctly suggested.

In the actual drawing the real lines may be sketched in charcoal from point to point at the same angle determined by the plumb, and the corrections made accordingly, these straight lines being of course erased afterward.

VALUES.

The term "value," as understood by artists, is used to express the *comparative relation of tones to each other*, irrespective of color. There may be many different colors before us all of the same value; also, there may be only one color used in a drawing, yet many different values are seen, which goes to show that we are to compare tones and not colors.

For example, in drawing or painting a landscape we look at the tone of the trees against the sky and observe which is the darker. If a stormy, heavy sky is seen behind light, feathery, green trees we see that the sky is darker in value.

If, on the contrary, trees with dark, rich foliage are observed to be strongly relieved against a bright, sunny sky, we perceive at once that the sky is lighter in value than the trees. In like manner we compare the rocks with the water, the

fence with the road, and so on, according to the different objects to be regarded in the picture.

In drawing a head in charcoal or crayon it is well to establish at once the darkest value in the whole, selecting the deepest spot of shadow with which all the other tones of dark may be compared.

Look for instance, at the shadow over the eye or under the nose, which are generally very dark, and compare it with the shadow on the cheek, behind the ear, or under the chin. In the same way decide upon the highest light in the face. Say it is found upon the forehead or on the cheek bone. Be sure that it is the brightest spot in the face, and then compare all the other degrees of light with this.

By studying in this way, and observing the comparative variety of these tones, we arrive at correct values.

This is a most important quality in art and can not be over-estimated, for upon a just appreciation of the values in a pict-

ure depends its truth. This also serves to illustrate the necessity of making studies directly from nature whenever possible.

CHAPTER VI.

CRAYON PORTRAITS.

Crayon is especially adapted to portraiture, on account of the brilliant effects of which it is capable of producing, as well as the great softness and delicacy of finish which may be obtained by its use.

Portraits should, of course, always be taken from life if possible, though if the person be an invalid or is for any other reason unable to give many sittings, a photograph may be used for the beginning. The portrait is carried on from this until well advanced; if one or two sittings from life can then be had in finishing, it will be a great advantage, especially in regard to the expression.

In portraits of children a photograph is frequently a great assistance, particularly

if the artist has not had much experience.

In all such cases, however, it is best to decide upon the pose, and sketch it from life, and then have the photograph taken in the pose you have selected.

In this way, the light and shade are arranged to suit the artist, and the pose being decided upon by him, the portrait will have the effect of being drawn from life instead of being merely a copy from a conventional photograph.

In general the effect of light used by photographers is exactly the reverse of that chosen by artists. It will be noticed that ordinary photographs have the greater part of the face either in shadow or covered by strong half-tints.

An artist, on the contrary, in posing a head for a portrait, prefers exactly the opposite arrangement, selecting broad and simple effects of light with only enough shadow to give the necessary variety and relief to the features.

When arranging the preliminaries for a

portrait, there are several things to be considered.

In the first place, study the head carefully and see which view is most agreeable. Sometimes features in the same face look differently when seen from opposite directions. Some noses or mouths look well on one side and distorted on the other.

A very broad face should not be given a full front pose, but would look better seen in three-quarter.

A very retreating chin must not be seen in a profile view.

This same pose, however, for a person with a cast in the eyes is preferable, and so on. After all such matters have been considered, see that the head is not thrown up too high, as it will make the nose look short, while lowering the chin too much will make the nose look long. A good rule is that the eyes of the sitter should be on a line with those of the artist as he sits or stands at his work.

The method most generally in use for crayon portraits is that described in the

CHARCOAL AND CRAYON. 61

preceding pages, in which the stump is used. All the old-fashioned ways of stippling and hatching are seldom resorted to, and not considered artistic.

In drawing a life-sized head the artist must not be too far from his subject, the easel being placed about four or five feet distant. It is well to get up and walk back occasionally, looking at the work from a distance so as to see the general effect.

There are several different kinds of paper used for crayon portraits, some artists preferring one make, some another. The ordinary "Lalanne" and "Michelet" papers used for charcoal and crayon studies are a little too rough in texture to please every body, and do not produce quite so fine a finish as is desirable. They come in too small-sized sheets for a large portrait head, for which one wants plenty of room.

This, however, is merely a matter of taste, that can be indulged when one has become sufficiently proficient in the work

to judge for himself. We will suggest that Whatman's crayon paper is one of the most satisfactory ; this comes in large sheets, and should be stretched before using in the manner already described. A good sized stretcher for an ordinary portrait is 20x24.

If more of the figure than the shoulders is to be seen, a larger size would be better.

The portrait is first lightly sketched in with charcoal, and if the student is not very proficient in drawing from life it is better to make the first sketch upon an ordinary sheet of charcoal paper.

When all corrections are made, and the general proportions of the face appear to be right, the outline is transferred to the stretcher in the following manner :—

Take the sheet of charcoal paper on which the sketch is made, and with a stick of charcoal "scribble," so to speak, all over the back, so that the paper is entirely covered behind your sketch.

Now lay this sheet with the face upward

on the clean stretcher, placing it so that the head will come in exactly the right place, neither too high nor too low.

Fasten it with pins at the top and bottom, so that the paper will not slip, and then with a sharp, hard lead-pencil carefully go over the outline, and every important part of the face and head. If the paper should move in the least the whole thing is spoiled, therefore it is best in transferring to lay the drawing upon a table till finished. Remember not to rest the hand heavily upon any portion of the paper except the line to be traced, as every touch leaves a black spot beneath.

On removing the sketch a perfect outline will be found upon the stretcher, which will be a sufficient guide to the proportions and general likeness. Now, with a sharply pointed charcoal stick begin to draw in the head, following the outline, block in the features, massing the shadows in the face and hair.

Do not begin to use the crayon until the general likeness is assured, for the

paper must not be roughened by too much erasing.

Use the soft cotton rag for dusting off charcoal whenever you can, instead of bread, as too much rubbing with bread will grease the paper; for very large spaces, where erasing is necessary, use Faber's India rubber.

When the crayon is put on, advance slowly, remembering that in a portrait there is much more careful work than in an ordinary life study, and that there are many more things to be considered than merely the drawing. The likeness is to be secured, which is sometimes a difficult thing even for those with experience.

This is accomplished gradually; the student must not always expect to see the likeness in the first sketch; it comes by degrees, as the drawing progresses, and it is a good rule to draw the head in exactly as you see it, emphasizing the salient points, no matter how ugly it may appear. Do not attempt to improve and

modify until the drawing and general likeness are secured.

The expression comes last of all, and with it the beauty. If you attempt to make the face pretty at first, you will weaken the drawing and lose the character. For this reason, many artists make it a rule never to show their portraits until finished. The sitter does not understand the methods of working and is tempted to criticise, which renders the worker timid.

After the head is put in with the crayon and modeled with the stump, in the manner described in a previous chapter, the finishing is carried on with the crayon point, the small stump, and the pointed rubber stump, which is found more useful than bread at the last.

The animated expression is put in the eyes by dark touches in the pupil and under the lids, while sharp lights are accented in the iris and on the eyeball.

The form of the under lid must be carefully studied.

The nose, also, has much to do with the expression; especially the shape of the nostrils, and the direction of the lines at the side of the nose running down to the mouth. Observe whether the nostrils droop downward at the outward edge; this gives a serious expression; if, on the contrary, the line is elevated, it tends to give a bright and animated appearance to the face.

The mouth, of course, is of great importance, and influences the expression more than any other feature; when smiling, the corners are turned upward, and the lines or dimples are curved in an outward direction. In a sad face the corners of the mouth drop downward and the lines grow straight.

If the student learns to look for such indications in many faces, he will find more suggestions of importance to aid him in developing the expression. Without such knowledge, he may accidentally reverse these conditions, and work on blindly, puzzling himself vainly to find out where

he is wrong and why the expression is just the opposite of what it should be.

THE HAIR.

In drawing the hair, no matter how elaborate its arrangement, it must be blocked in at first in simple flat masses of light and shade without any attempt at detail. Try, however, to give the general character of the hair in putting in the form of the shadows where they meet the light. In smooth, black hair, the effect will be large masses of black with sharp, clearly-defined high lights.

Light curly hair will have much lighter tone in the shadow and much less brilliant lights.

After the hair is thus laid in with charcoal and the stump, the crayon is taken up.

The half tints are studied and the deep accents of dark put in the shadows, always following the outline of the form of each shadow very carefully.

Avoid putting in a number of lines to

represent hair, as this destroys the effect and means nothing. All details are expressed by carefully rendered light and shade.

In finishing, the high lights are taken out with bread rolled to a point, or if more convenient, the india-rubber stump is used.

Soften the hair where it touches the face, never leaving a hard, dark line. When a tone is too dark, it is not always necessary to use either bread or rubber, but first try rubbing with the stump, which may be found sufficient.

BACKGROUNDS.

A background gives relief and importance to the head, and should be managed with judgment.

In the first place, never make the background exactly the same value as the head. If the hair is light and the general effect of the face fair and delicate, the background should be darker than the head, though not too dark.

CHARCOAL AND CRAYON.

Everything must be harmonious, and a spotty appearance is to be avoided.

For instance, a very light effect of hair and face with a moderately dark dress and a jetty-black background is very bad. Also, a head with black hair, white dress and very light background. All violent contrasts should be avoided.

Put the background in at first with charcoal only, using parallel lines in one direction, then crossing them diagonally. After this take the large stump and rub these lines into one tone, yet leaving a slight suggestion of the lines to show through.

Put in this tone only around the shoulders and lower part of the head, leaving the upper part of the paper bare, or nearly so.

In this way try the effect, working slowly and adding more charcoal as the tone needs to be darker.

When you have decided that the background has the right effect in relation to the head, use the crayon point in the same way as the charcoal, putting in crossed

lines and rubbing them together again with the stump until a transparent effect is achieved, which will give atmosphere and relieve the head.

If you get on too much crayon rub it all over with a soft rag. This is an excellent thing to do occasionally, as it softens and unites the whole while making the tone lighter.

Sometimes in finishing, a few touches of the rubber point may be used at the edges of the background and where it softens off at the top. Use the rubber in the same manner as the crayon point, making light lines crossing obliquely.

Remember that hardly any appearance of lines must be seen. When all is done they must be so softened with stump and rag as to present almost the appearance, at a little distance, of an even tone.

In some cases the background may be carried up higher than the middle of the head, but it is very rarely necessary to surround the whole head with it.

Sometimes a very light tone may be

put all over the paper with the large stump and rag.

In this case the lines are only used at the darkest part around the shoulders. These matters must be determined by individual taste, and the composition of the portrait, as it is impossible to make general rules for every case.

Never attempt to make landscape backgrounds or effects of drapery and still-life behind a simple portrait head. Every thing should be kept subordinate to the face, which is the most important thing of all. Never use white chalk or crayon with the black in such portraits; take all lights out with bread, or leave the paper clean.

DRAPERY.

All drapery in a crayon portrait must be treated as simply as possible, being regarded only as secondary in importance to the head, which is, of course, the main object of interest.

All elaborate trimmings or pronounced fashions should be avoided.

Different kinds of material are interpreted by carefully studying the different forms of the lights and shadows in each. For instance, black satin is rendered by large masses of black, as black as crayon can be made with sharp, narrow high lights, so light as to be almost white.

In black silk, the masses of dark are lighter in their general tone, and the lights less sharp and brilliant.

The different colors are represented by lighter or darker tones, as the case may be.

In black velvet, the masses of dark are softer than in satin and not so jetty black, while the lights are less brilliant and more diffused in effect, leaving more half tints than are seen either in silk or satin. In black cloths the lights are quite low in tone and the darks are not very black, no sharp high lights are seen at all, both light and shade taking large and simple forms.

White stuffs, such as lace, muslin, etc.,

are also kept simple in effect, and are laid in with a very delicate tone all over the mass of light, and the high lights are taken out with bread.

The shadows should also be delicate and transparent and not too dark. White hair is treated in this way also, the character of the hair being indicated by the form of the lights.

When there is a white cap upon the head or lace of any kind, do not make it too prominent, but carefully study its value in relation to the face.

CHAPTER VII.

CHARCOAL AND CRAYON DRAWING WITH THE POINT ; LANDSCAPES, PROPORTIONS, ETC.

This method is principally used by artists in making drawings for illustration, as stump drawings can not well be reproduced. The manner of working is as follows :—

Sketch in the outline with the charcoal stick, sharpened to a point, and then proceed to block in the shadows, which must be drawn in with careful attention to the form, for the reason that it is best to make a distinct outline of each mass of shadow where it meets the light. These shadows are now filled in with the pointed charcoal, used in close parallel lines until a

CHARCOAL AND CRAYON. 75

flat, even tone is obtained. It is not necessary that these lines should be distinct, or of exact regularity, as in the very darkest shadows no lines at all should be seen. The half tints are managed in the same way with the point, which may be used in the direction of the features to some extent.

The main thing to be remembered is that no stump must be used, nor the charcoal rubbed in any way. For erasing, bread is the best, though rubber is sometimes found useful.

The crayon point is employed in exactly the same way as the charcoal, the directions applying equally to both. All drawings should be fixed as soon as finished.

PROPORTIONS OF THE FIGURE.

A few conventional rules for the general proportions of the face and figure may be found useful to the student in drawing from life, and are regulated according to the standard of beauty as determined by

the Greek statues. Such proportions will naturally vary in individual cases, yet are valuable as a foundation, which may be modified when necessary.

The height of a well developed man is eight heads or eight times the length of his own head.

The height of a woman, seven heads.

The human figure may be divided into four parts of equal length, viz. : from the top of the head to the arm-pit, thence to the middle of the body, thence to the knees, thence to the soles of the feet.

The arms extended straight out at right angles to the body will measure from finger-tip to finger-tip the length of the figure from crown of head to sole of foot.

The face may be divided into three parts. From the top of the forehead to the root of the nose; from there to the bottom of the nose, thence to the bottom of the chin. The ear is the length of the nose, and its general direction is parallel to it.

From the top of the shoulder to the

elbow measures twice the length of the face, or one head and a half.

From the elbow to the wrist one head.

The hand measures three-quarters of a head from the tip of the middle finger to the wrist.

The foot measures one-sixth of the whole length of the body.

LANDSCAPE.

Charcoal is a favorite medium with many artists for landscape subjects, and it is, as before stated, especially useful in sketching from nature.

In beginning to draw a landscape in charcoal, first sketch in lightly the horizon line, the outlines of the trees and different objects, in their general aspect.

It is always well to select a subject where there is a good effect of light and shade and sufficient variety to give interest.

After the composition is sketched in, look for the large masses of shadow, and divide the whole into two distinct masses

of light and shade, as in figure drawing. The sky is covered with a light tone, at first, and even the masses of light are also covered with a delicate half-tint.

The whole drawing may be made entirely with the point if it is desired, but the French artist Allongé, who is celebrated for his charcoal landscapes, prefers the use of the stump, with the point in finishing.

If in place of the stump the finger sometimes is used to blend the charcoal, and for rapid sketches, this is very effective.

After the general masses are put in, the details are drawn with the point, being somewhat softened with the stump, though in trunks of trees, dark branches, rocks, etc., the marks of the point are left unsoftened to give strength.

The lights are taken out with bread or rubber; sometimes a piece of chamois skin is found useful in lightening a tone. The light clouds are taken out with bread from the sky which has been covered with a half-tint, and the dark clouds are put in

with the stump or point, according to the method employed.

In sketching from nature out of doors, it is always well to adopt some prominent object as a standard of measurement; for instance, take a house or tree in the middle distance, and compare this in height with objects in the background and foreground. In this way your perspective, if simple, may be made correct without any elaborate rules.

Objects in the distance are naturally smaller than those in the foreground, and the exact proportions can be determined by comparative measurement.

In drawing a road or path, notice that it will become narrower as it recedes into the distance. For those who have never studied perspective such suggestions are useful.

It is very important also that the values should be carefully studied; it is a good thing to establish the darkest spot of shadow in the whole sketch, and compare all the other darks with it, as already sug-

gested in figure drawing. Determine also the brightest light, and let the other lights be in their proper relation to it.

Either crayon or charcoal, or both, may be used for landscapes; it is always better to sketch in the drawing with charcoal, even if crayon is used afterward.

Some very good effects are produced by using crayon or charcoal on tinted paper, either gray, blue, or light brown, and, leaving the tone of the paper for the half-tint, put in the high lights with white chalk.

In such drawings the stump must not be used, nor should the tones be rubbed or blended in any way. Use the crayon or charcoal point in the manner already described, and put the lights in at the last with crisp, strong touches.

As the student continues his practice he will find out the resources of these most interesting materials, and will develop new possibilities for himself as he becomes more adept, but it must be remembered that there is no "royal road to learning,"

and to succeed in acquiring proficiency in drawing of any kind, requires patience and perseverance, with constant practice.

APPENDIX.

EXPLANATION OF THE PLATES.

The intention of the author in presenting these plates is that the student, by copying a series of progressive drawings, may be prepared to study from the cast and from life. For those who are entirely inexperienced, it is much easier to learn this method from such flat copies at first, as it not only teaches the use of the materials, but familiarizes the student with the forms of the different features, so that when confronted with nature he finds his difficulties considerably lessened.

PLATE I.

This plate is intended to show the drawing of the human eye and mouth in

different positions, as well as to familiarize the student with the general form of these important features. Only charcoal sharpened to a point is necessary for these outlines, which should be carefully practiced before proceeding to Plate II.

PLATE II.

This study is intended for those who have never drawn from the cast, and have had no practice in using charcoal. A. represents the manner of beginning a drawing. Make a dot on the paper for the top, and one for the bottom of the fragment to ascertain where to place the lines, and then with a sharply pointed charcoal stick, draw the general form of the outline in the manner shown in the plate, without attempting any detail. The shadows are then blocked in squarely with the point. When the proportions are thus ascertained to be correct, proceed to finish the drawing as is seen in B.

To do this, rub the shadows with the stump till one flat, even tone is obtained,

and carefully draw the outline, turning the angles into curves.

This plate is for the most elementary practice in drawing, and no further degree of finish than this should be attempted, until the student has learned to do this much well.

PLATE III.

This represents a simple study of the hand, drawn from a cast. A. indicates the manner of laying in the study, the curved lines being drawn to show the direction and movement of the fingers.

In B. the stump is used in the shadows, and the modeling is carried on further than in Plate II., the half-tint being added. The outline is carefully finished with the pointed crayon, which is also used in the shadows.

PLATE IV.

The part drawn from the cast here represented, is laid in with charcoal, as in Fig. A., and then carried on in crayon

as in Fig. B. The outline is carefully drawn and the shadows blocked in squarely at first as usual, and then changed with great care into the necessary correct forms.

It will be noticed that this study is a little further advanced than those already given, more detail being shown, as well as a little greater variety in the half-tints. The straight lines across the base and ends of the toes serve to direct the eye to the difference between their general direction and a perfectly horizontal line.

PLATE V.

In this plate the whole profile view of a face is given, Fig. A. representing the way to lay in a head. The straight lines outside may be ruled, as they have nothing to do with the drawing, but are merely mechanical aids by which the angle of the features is determined.

In B. the modeling of the features is carried on still further than in any of the

preceding studies, the half-tints and shadows, however, being still kept flat.

PLATE VI.

This plate gives a more difficult study in the three-quarter view of a male head. In laying in the drawing, as in Fig. A., be careful to get the proportions as perfectly correct as possible before proceeding to carry the modeling further, as in Fig. B.

This head, though more finished than any other yet given, purposely stops short of the final extent to which such drawings may be carried, as the object of the author is to familiarize the student with each step by the way. In the smaller touches about the eyes, nose, etc., the pointed rubber stump will be found more available than bread. For the large masses of shadow it would be well to rub off some sauce crayon on a small piece of drawing paper and fasten it one side of the easel, or, if preferred, rub the pointed crayon on the rough paper until

a sufficient quantity adheres. The stump is rolled around in this until sufficient is taken up to cover the large mass of shadow. The more careful work is carried on with the pointed Conté crayon, small stump, and pointed rubber, or bread, as before explained.

PLATE VII.

Plate VII. is intended to prepare the student for drawing the full length figure from the cast, and should be carefully copied. An excellent exercise would be to draw Fig. A. several times first, in order to practice the manner of beginning such a drawing; then when this is fully mastered proceed to finish as in Fig. B., which in this plate shows a fully completed drawing from the cast.

PLATE VIII.

This plate represents a study of the male figure taken directly from life, and is a most carefully finished drawing in every respect. Fig. A. shows the manner

of beginning such a figure; the outline is sketched in with long, sweeping lines at first, to determine the direction of the pose; the proportions are noted and the outline corrected, though drawn in angles, the general masses of shadow being blocked in as usual.

In Fig. B. the crayon and stump are taken up and the drawing is carefully carried on as shown by the plate, until completed.

THE END.

www.ingramcontent.com/pod-product-compliance
Lightning Source LLC
Chambersburg PA
CBHW020926180526
45163CB00007B/2899